Lemon yellow

Cerulean blue

The
Watercolour
PAINTER'S
POCKET
PALETTE

Instant, practical visual guidance

on mixing and matching

watercolours to suit all subjects.

Moira Clinch

SEARCH PRESS

A QUARTO BOOK

Published in paperback
1998 by
Search Press Ltd
Wellwood
North Farm Road
Tunbridge Wells
Kent TN2 3DR
United Kingdom

Reprinted 1999, 2000,
2001 (twice), 2002, 2003

ISBN 0 85532 886 X

This book was designed
and produced by
Quarto Publishing plc.
The Old Brewery
6 Blundell Street
London N7 9BH

While every care has
been taken with the
printing of the colour
charts, the publishers
cannot guarantee total
accuracy in every case.

THE
COLOURS

page **10**
Cerulean blue

page **11**
Cobalt blue

page **12**
French
ultramarine

page **18**
Terre verte

page **19**
Viridian

page **20**
Sap green

page **21**
Hooker's green
dark

page **29**
Naples yellow

page **30**
Yellow ochre

page **31**
Cadmium
orange

page **36**
Bright red

page **40**
Rose doré

page **41**
Permanent rose

page **44**
Cobalt violet

page **45**
Winsor violet

page **51**
Venetian red

page **52**
Burnt umber

page **53**
Sepia

page **56**
Payne's gray

page 13
Winsor blue

page 14
Prussian blue

page 15
Indigo

page 26
Lemon yellow

page 27
Aureolin

page 28
Cadmium
yellow

page 37
Cadmium red

page 38
Alizarin
crimson

page 39
Rose madder
genuine

page 48
Raw sienna

page 49
Raw umber

page 50
Burnt sienna

page 57
Davy's gray

page 60
Ivory black

page 61
Chinese white

CONTENTS

USING THIS BOOK

THE PURPOSE OF THIS BOOK is to provide the watercolour artist with an at-a-glance guide to over 800 mixes and overpainting effects. More experienced water-colourists will already know their favourite colour combinations, but hopefully this book will yield some surprises, even in the case of colours that the artist uses regularly. The beginner can cut out trial and error time by selecting a possible basic palette to work with.

Most artists tend to work with a limited number (approximately 12) of colours, known as a basic palette. The choice of colours is a matter of personal preference, but since paint manufacturers produce a vast number it can some-times be confusing. *The Painter's Pocket Palette* helps not only in the selection of colours but also more creatively, by exploring the possibility of adding a new

Each page features one of the 34 chosen colours in various permutations. This is referred to as the main colour (1). For a visual guide to these colours see pages 2 and 3. Each main colour is mixed with a constant basic palette (2), see opposite, which is repeated on every page. The main colour is also shown as an area of dry flat wash with the same basic palette overpainted as brushstrokes on top of it (3). The symbols (4) denote various characteristics of the main colour (see page 9).

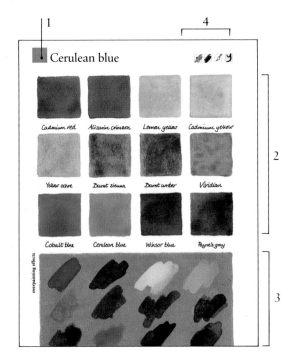

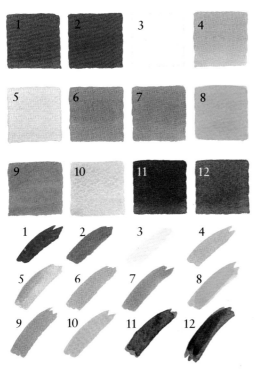

This is the basic palette used throughout the book, shown here without the addition of the main colour

1 *Cadmium red*
2 *Alizarin crimson*
3 *Lemon yellow*
4 *Cadmium yellow*
5 *Yellow ochre*
6 *Burnt sienna*
7 *Burnt umber*
8 *Viridian*
9 *Cobalt blue*
10 *Cerulean blue*
11 *Winsor blue*
12 *Payne's gray*

REMEMBER

*The main colour is featured **once** on its own page. The basic palette repeats **twice** on every page.*

and hitherto unknown colour to your paintbox. The 34 colours chosen are the more familiar ones, and all are reliable and durable (see symbols p9).

How many times have you almost bought a new pigment, or actually bought it only to find yourself reverting to the old safe, familiar mixes? The page-by-page chart layout of the book provides accessible and easy-to-compare visual information, so that using new colours ceases to be an alarming and hit-and-miss affair and becomes an exciting and creative one. You can see at a glance how to achieve the colour mix you want, and just as importantly you can see when a mix is not appropriate for a particular effect.

THE BASIC PALETTE

The basic palette chosen for the book is shown above, but this is only a suggested starting point; you may add or replace colours as you choose. For example, you may prefer to use French ultramarine instead of Winsor blue as part of your own selection.

MIXING SECONDARY COLOURS

The secondary colours, green, orange and purple, can be bought as various hues in tube or pan form, but generally more colours can be achieved — and it is more fun — if you mix your own.

These pages show how by mixing two primaries together, or by mixing a primary with one of the proprietary secondaries, such as sap green or one of the purples, you can create both intense and muted secondaries. An extra feature is a graduated colour strip showing degrees of mixing the two colours.

There are some secondary hues, however, such as viridian and cadmium orange, which cannot be mixed from two primaries as they have an intensity which it is impossible to reproduce.

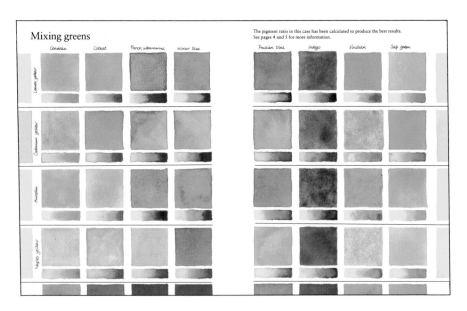

Mixing greens

This page showing secondary colour mixing is repeated three times in the book to show various mixes of green, orange and purple.

UNDERSTANDING THE MIXTURES

When mixing secondaries, you will need to know which of the primaries to use, as there are many versions of each one. As you can see from the colour wheel, each one has a bias towards another, for instance cadmium red veers towards yellow, so it makes sense when trying to achieve an intense secondary to exploit this bias.

Conversely, if you want to mix a neutral secondary or neutral colours, mixing colours that contain the opposite or complementary colour on the colour wheel will give a muted or even muddy result.

▶ *When colours are placed next to one another you can see the colour bias clearly.*

▼ *These charts show how the choice of the primary colour affects the mixture. Those closest together on the wheel create intense secondaries, while those furthest apart create neutrals.*

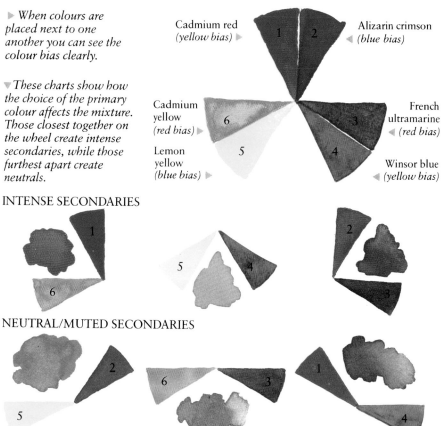

Cadmium red
(yellow bias) ▶

Alizarin crimson
◀ (blue bias)

Cadmium
yellow
(red bias) ▶

French
ultramarine
◀ (red bias)

Lemon
yellow
(blue bias) ▶

Winsor blue
◀ (yellow bias)

INTENSE SECONDARIES

NEUTRAL/MUTED SECONDARIES

UNDERSTANDING THE SYMBOLS

Every watercolour pigment has its own characteristics, and all the colours shown in this book have been coded to help you identify at a glance the different properties.

Transparency

One of the most exciting, if unpredictable, qualities of watercolour is its ability to impart colour while allowing underlying layers to remain visible to a greater or lesser degree. Linked to this is the way in which pigments can be diluted with water so that the white of the paper itself dilutes the colour, rather than 'polluting' the colour with white, as is the case with opaque paints. Because of the transparency of watercolour, the usual way of working is from light to dark, gradually building up layers. Transparency, however, is relative, and because some pigments are considerably more opaque than others they are categorized as transparent or semi-transparent and semi-opaque.

The amount of water used is a matter of personal preference, but generally a

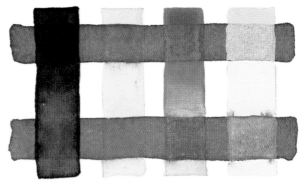

The chart shows how both dark and opaque pigments can cover earlier layers of colour when used with very little water (top). The more water used to dilute the pigment the more transparent it becomes (bottom).

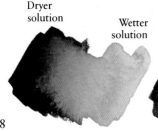

Dryer solution

Wetter solution

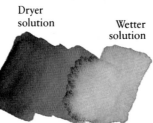

Dryer solution

Wetter solution

When working wet in wet the wash with the higher proportion of water will tend to run into the mix which contains more pigment, especially if the latter is applied first.

THE SYMBOLS

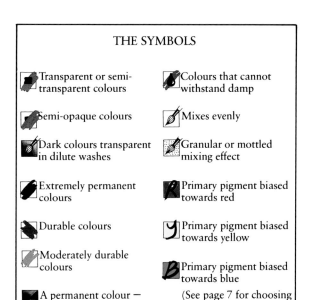

Transparent or semi-transparent colours

Semi-opaque colours

Dark colours transparent in dilute washes

Extremely permanent colours

Durable colours

Moderately durable colours

A permanent colour – that fades in the light and recovers in the dark

Colours that cannot withstand damp

Mixes evenly

Granular or mottled mixing effect

Primary pigment biased towards red

Primary pigment biased towards yellow

Primary pigment biased towards blue

(See page 7 for choosing the right primary for a mix)

MIXES IN THIS BOOK

All the colours in this book have been mixed under control conditions, with approximately the same amount of water used for each one. This has been calculated to create a medium-strength mix, which provides the most useful guidance. Stronger and weaker amounts can be visualized and experimented with if desired.

PIGMENT RATIO

On main colour pages:
60% main colour
40% basic palette colour
unless stated otherwise

tighter more detailed style uses a higher mix of pigment to water than a looser one. As a rule the more water used the more unpredictable the result. No two mixes will ever contain the same amount of water, and the solution with the higher percentage of water will 'run' into the less diluted mix. This 'pushes' the pigment creating intriguing, if unpredictable, effects. Tanalizingly, it is seldom possible to recreate them, as they are never exactly the same.

Permanence

Watercolours are graded for permanence, the main categories being extremely permanent, durable, moderately durable and fugitive. Some colours which are durable in strong washes are less durable when applied in thin washes, and other colours fluctuate; they fade in sunlight and recover in the dark.

Mixing qualities

Some pigments mix very evenly whilst others mix creating granular or interesting mottled effects.

 # Cerulean blue

Cadmium red

Alizarin crimson

Lemon yellow

Cadmium yellow

Yellow ochre

Burnt sienna

Burnt umber

Viridian

Cobalt blue

Cerulean blue

Winsor blue

Payne's gray

overpainting effects

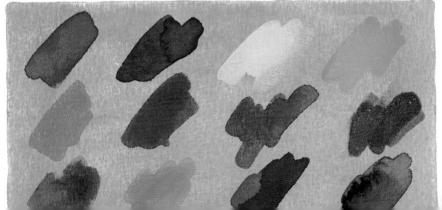

10

Cobalt blue

Cadmium red

Alizarin crimson

Lemon yellow

Cadmium yellow

Yellow ochre

Burnt sienna

Burnt umber

Viridian

Cobalt blue

Cerulean blue

Winsor blue

Payne's gray

overpainting effects

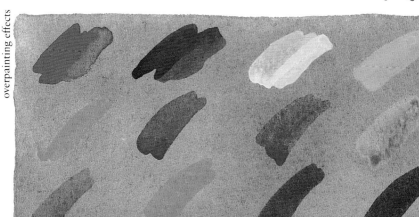

11

 # French ultramarine

Cadmium red	Alizarin crimson	Lemon yellow	Cadmium yellow

Yellow ochre Burnt sienna Burnt umber Viridian

Cobalt blue Cerulean blue Winsor blue Payne's gray

Cadmium red Alizarin crimson Lemon yellow Cadmium yellow

Yellow ochre Burnt sienna Burnt umber Viridian

Cobalt blue Cerulean blue Winsor blue Payne's gray

overpainting effects

13

 # Prussian blue

Cadmium red

Alizarin crimson

Lemon yellow

Cadmium yellow

Yellow ochre

Burnt sienna

Burnt umber

Viridian

Cobalt blue

Cerulean blue

Winsor blue

Payne's gray

overpainting effects

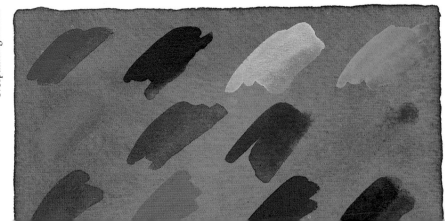

14

Cadmium red

Alizarin crimson

Lemon yellow

Cadmium yellow

Yellow ochre

Burnt sienna

Burnt umber

Viridian

Cobalt blue

Cerulean blue

Winsor blue

Payne's gray

overpainting effects

15

USING SKY BLUES

Bosham Clouds
7ins × 10ins

THE BLUE PIGMENT chosen to represent the sky is a matter of personal preference, but generally the blues which are biased towards yellow give the effect of sunlight, and when strongly diluted with water look warm and hazy. Paradoxically, those containing traces of red can seem cooler, and when applied as a thin wash create a crisp effect.

To capture the fluidity of cloud formations the artist needs to analyse the tones and shapes very quickly, and then to simplify them. Highlights, wispy clouds or the tops of 'cotton wool' clouds tops are usually left as white paper. The mid-tones and the dark undersides can be proprietary grey watercolours or pigments such as ultramarine and cadmium red mixed with touches of other colours for variety.

▶ *The blue sky was a medium to weak dilution of ultramarine, with the contrast between wet, uneven washes and areas of dry brushwork giving life to this single pigment. In general, blue sky colours are better unmixed unless painting sunrises or sunsets.*

◀ *Grey cloud areas were achieved by various mixtures of ultramarine and touches of cadmium red, the latter giving subtle warmth and interest to the grey, while rapid streaking brushstrokes were used for the dark undersides of the clouds.*

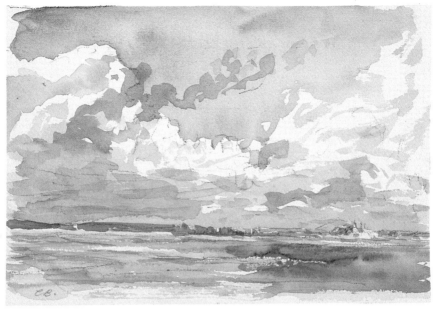

The flat foreground landscape has sunlit patches of yellow ochre, areas of muted viridian, and for the far distance touches of ultramarine.

 # Terre verte

Cadmium red

Alizarin crimson

Lemon yellow

Cadmium yellow

Yellow ochre

Burnt sienna

Burnt umber

Viridian

Cobalt blue

Cerulean blue

Winsor blue

Payne's gray

overpainting effects

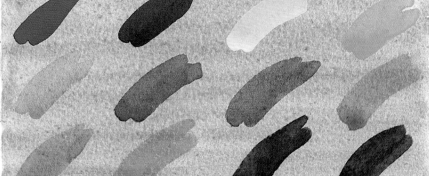

18

Viridian

Cadmium red

Alizarin crimson

Lemon yellow

Cadmium yellow

Yellow ochre

Burnt sienna

Burnt umber

Viridian

Cobalt blue

Cerulean blue

Winsor blue

Payne's gray

 overpainting effects

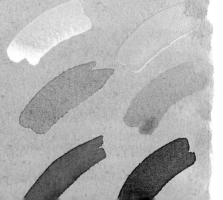

19

Sap green

Cadmium red

Alizarin crimson

Lemon yellow

Cadmium yellow

Yellow ochre

Burnt sienna

Burnt umber

Viridian

Cobalt blue

Cerulean blue

Winsor blue

Payne's gray

overpainting effects

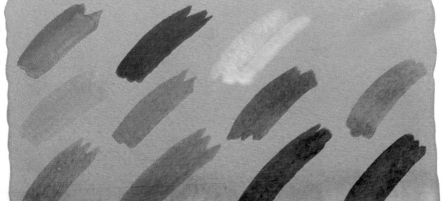

20

Cadmium red Alizarin crimson Lemon yellow Cadmium yellow

Yellow ochre Burnt sienna Burnt umber Viridian

Cobalt blue Cerulean blue Winsor blue Payne's gray

overpainting effects

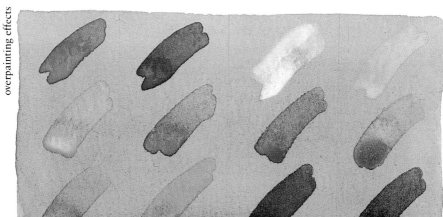

21

Mixing greens

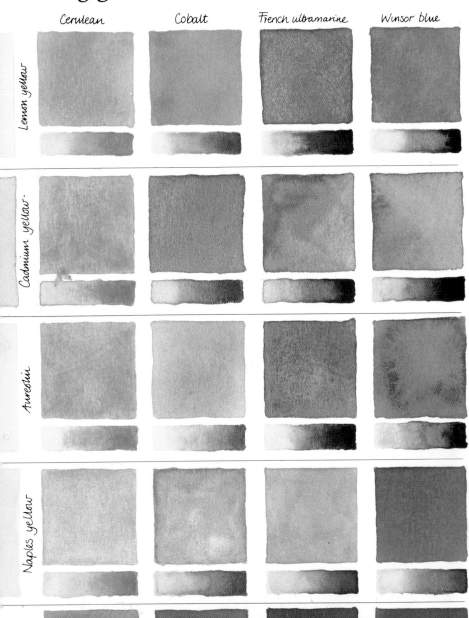

	Cerulean	Cobalt	French ultramarine	Winsor blue
Lemon yellow				
Cadmium yellow				
Aureolin				
Naples yellow				

The pigment ratio in this case has been calculated to produce the best results.
See pages 4 and 5 for more information.

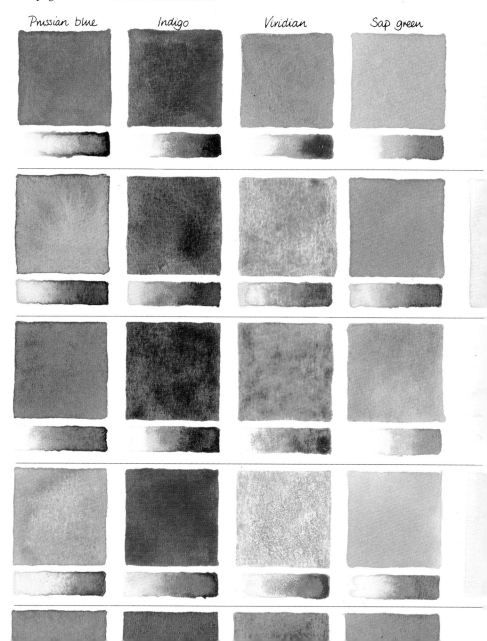

Prussian blue Indigo Viridian Sap green

USING AND MIXING GREENS

Rydal Water
15ins × 23ins

TO CREATE the effect of a landscape bathed in sunlight the artist used yellow ochre, cadmium yellow and lemon yellow as the basis of this painting. These colours were mixed with cobalt blue, Prussian blue, indigo and Paynes gray to create the various green hues. Most colours were mixed on a palette, but in some areas thin washes of colour were overpainted on dry base colours to achieve variety, and some shadow areas were applied 'wet in wet' so that they mixed on the paper.

▶ *The detailed leaf areas were gradually built up from a wash of yellow ochre with three subsequent layers of a Prussian blue and cadmium yellow mix.*

▲ *Yellow ochre was used as the first wash for the fields and trees in all the foreground areas. This gives warmth to the painting and accords with the colours of late summer.*

▲ *The blue of the sky was a simple, unevenly applied wash of cerulean blue, and the clouds thin mixes of Paynes gray and touches of lamp black. The billowing white cloud edges were achieved by leaving areas of the paper unpainted, as this produces a clearer, purer white than opaque white paint.*

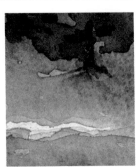

◀ *The shadow area was created by a thin wash of Paynes gray and indigo.*

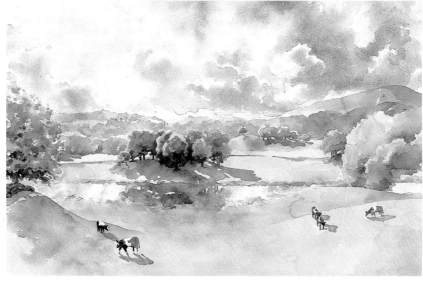

ARTIST Moira Clinch

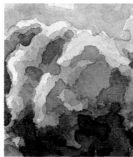

The trees are in effect backlit, as the direction of the sun is just off to the left of the picture area. The strong highlights on the edges of the trees were particularly important in conveying this, so base washes of lemon yellow were left untouched, and dark shadow areas built up to contrast with them.

Lemon yellow

Cadmium red	Alizarin crimson
Lemon yellow	Cadmium yellow

Yellow ochre	Burnt sienna
Burnt umber	Viridian

Cobalt blue	Cerulean blue
Winsor blue	Payne's gray

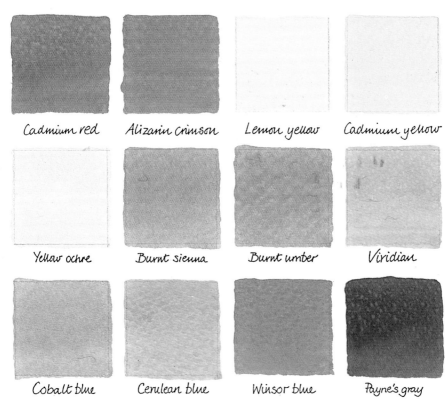

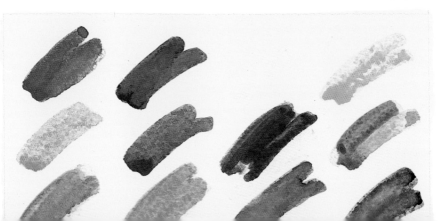

Aureolin

Cadmium red

Alizarin crimson

Lemon yellow

Cadmium yellow

Yellow ochre

Burnt sienna

Burnt umber

Viridian

Cobalt blue

Cerulean blue

Winsor blue

Payne's gray

overpainting effects

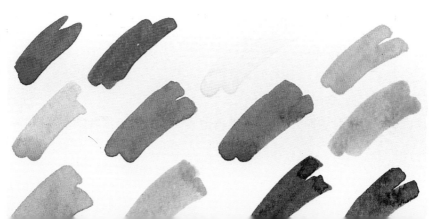

Cadmium yellow

Cadmium red	Alizarin crimson	Lemon yellow	Cadmium yellow
Yellow ochre	Burnt sienna	Burnt umber	Viridian
Cobalt blue	Cerulean blue	Winsor blue	Payne's gray

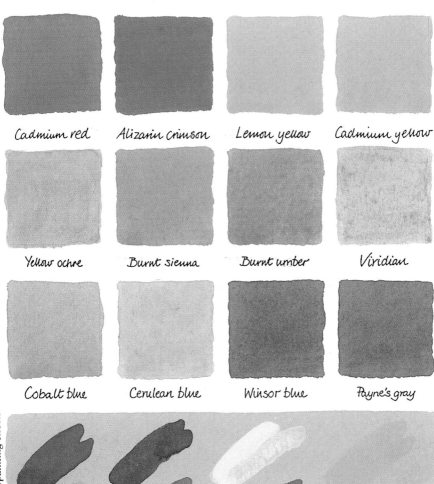

Naples yellow

Cadmium red Alizarin crimson Lemon yellow Cadmium yellow

Yellow ochre Burnt sienna Burnt umber Viridian

Cobalt blue Cerulean blue Winsor blue Payne's gray

overpainting effects

29

Yellow ochre

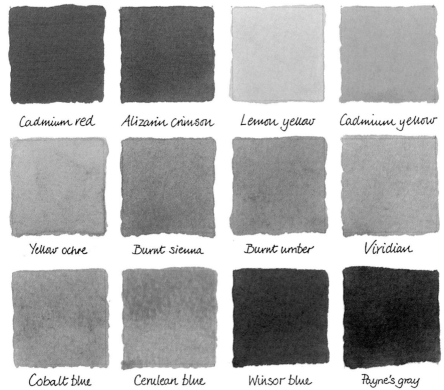

Cadmium red	Alizarin crimson
Lemon yellow	Cadmium yellow
Yellow ochre	Burnt sienna
Burnt umber	Viridian
Cobalt blue	Cerulean blue
Winsor blue	Payne's gray

30

Cadmium red

Alizarin crimson

Lemon yellow

Cadmium yellow

Yellow ochre

Burnt sienna

Burnt umber

Viridian

Cobalt blue

Cerulean blue

Winsor blue

Payne's gray

overpainting effects

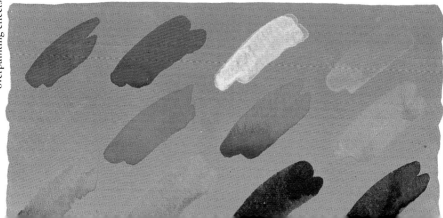

31

Mixing oranges

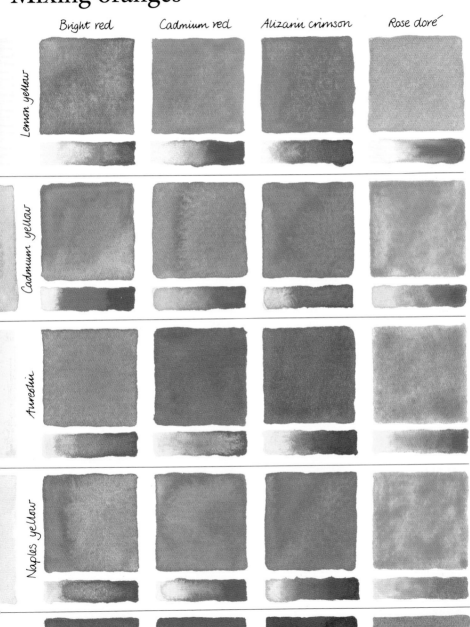

Bright red Cadmium red Alizarin crimson Rose doré

Lemon yellow

Cadmium yellow

Aureolin

Naples yellow

The pigment ratio in this case has been calculated to give the brightest oranges.
See pages 4 and 5 for more information.

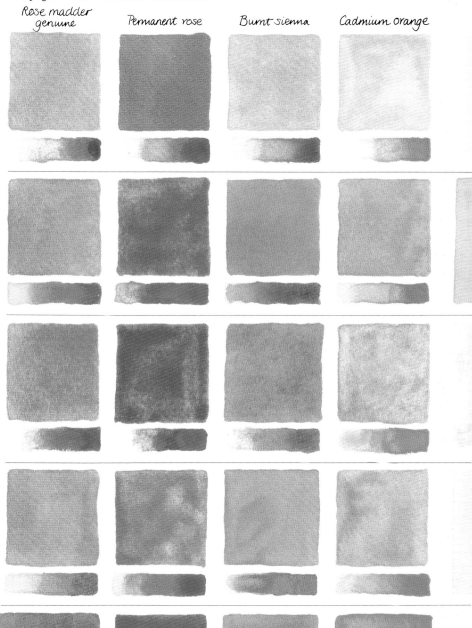

Rose madder genuine | Permanent rose | Burnt sienna | Cadmium orange

YELLOWS AND REDS

Flowers for Emily
11ins × 7½ins

THE FLICKERING PATTERN of pure white paper highlights in this painting conveys the impression of sunlight streaming in through the window. This warmth is further emphasized by the use of cadmium yellow in the various greens and the wet-in-wet additions of alizarin crimson even in the 'cool' shadow areas. The strong foreground shadow stabilizes the composition and contrasts with the flowers and the background window to emphasize the sunlit effect.

▶ *The green hues were various mixes of Prussian blue, indigo and cadmium yellow. To create both the pale greens of the background and the stronger greens of the foliage, the colours were mixed in different proportions and with varying amounts of water.*

▼ *Several subtle mixes were used for the yellow roses, the first being a very thin dilution of cadmium yellow. The darker layers were strong mixes of cadmium yellow with small amounts of cadmium red and Paynes gray.*

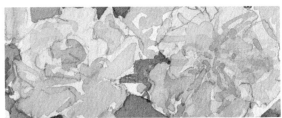

▲ *The red rose was begun with a flat underwash of cadmium red. The darker details of the petals were then painted with a strong mixture of cadmium red, alizarin crimson and a touch of indigo.*

◀ *The strong foreground shadow is a mixture of indigo with cadmium red and alizarin crimson, the two red pigments giving a touch of warmth which echoes the colour of the roses.*

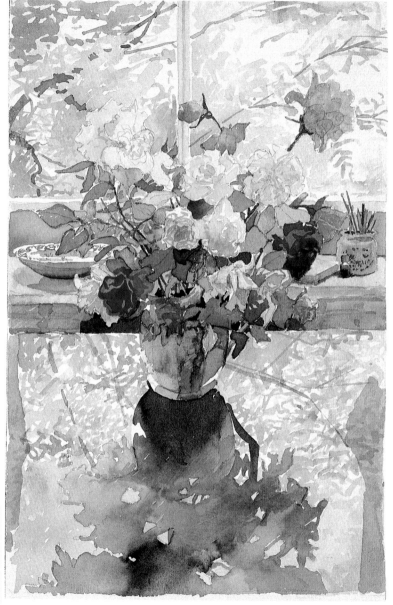

ARTIST Annie Williams

35

Cadmium red

Alizarin crimson

Lemon yellow

Cadmium yellow

Yellow ochre

Burnt sienna

Burnt umber

Viridian

Cobalt blue

Cerulean blue

Winsor blue

Payne's gray

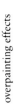
overpainting effects

 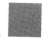

Cadmium red

Alizarin crimson

Lemon yellow

Cadmium yellow

Yellow ochre

Burnt sienna

Burnt umber

Viridian

Cobalt blue

Cerulean blue

Winsor blue

Payne's gray

overpainting effects

Alizarin crimson

| Cadmium red | Alizarin crimson | Lemon yellow | Cadmium yellow |

| Yellow ochre | Burnt sienna | Burnt umber | Viridian |

| Cobalt blue | Cerulean blue | Winsor blue | Payne's gray |

overpainting effects

Rose madder genuine

Cadmium red

Alizarin crimson

Lemon yellow

Cadmium yellow

Yellow ochre

Burnt sienna

Burnt umber

Viridian

Cobalt blue

Cerulean blue

Winsor blue

Payne's gray

overpainting effects

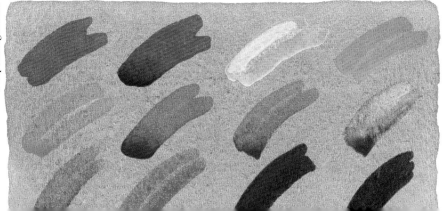

39

Rose doré

Cadmium red	Alizarin crimson	Lemon yellow	Cadmium yellow

Yellow ochre	Burnt sienna	Burnt umber	Viridian

Cobalt blue	Cerulean blue	Winsor blue	Payne's gray

overpainting effects

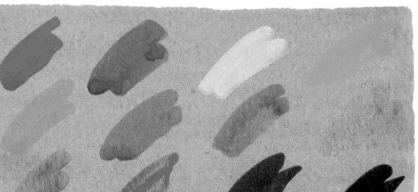

40

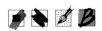

Permanent rose

Cadmium red

Alizarin crimson

Lemon yellow

Cadmium yellow

Yellow ochre

Burnt sienna

Burnt umber

Viridian

Cobalt blue

Cerulean blue

Winsor blue

Payne's gray

overpainting effects

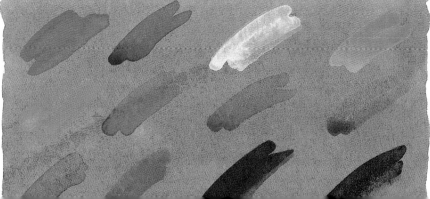

41

La Bougainvillea

19ins × 13ins

THE WARM COLOURS of burnt sienna, yellow ochre and burnt umber form the basis of this painting. The versatility of a single watercolour pigment is demonstrated by the fact that burnt umber was used to depict both the sombre nature of the gate and the delicate plasterwork of the wall. The only difference between the two is the amount of water used to apply the paint.

▷ *A strongly diluted flat underwash of burnt sienna was used as the basis for the brickwork. Individual bricks were then overpainted in diluted mixtures of cadmium deep red, raw sienna and yellow ochre.*

▼ *The highlights of the bougainvillea flowers were painted in concentrated rose madder carmine, while shadows were formed by subduing the colour with indigo.*

▲ *The iron gate was painted in a mixture of burnt umber and lamp black, with extra black and indigo for the shadow area.*

◀ *The shadow here was achieved by applying a medium dilution of Paynes gray over very thin dilutions of yellow ochre and raw sienna, and exceptionally thin washes of burnt umber.*

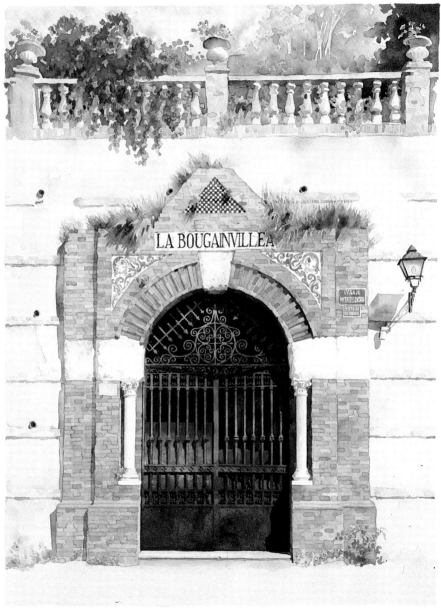

43

 # Cobalt violet

Cadmium red	Alizarin crimson	Lemon yellow	Cadmium yellow

Yellow ochre	Burnt sienna	Burnt umber	Viridian

Cobalt blue	Cerulean blue	Winsor blue	Payne's gray

44

Winsor violet

Cadmium red	Alizarin crimson	Lemon yellow	Cadmium yellow

Yellow ochre	Burnt sienna	Burnt umber	Viridian

Cobalt blue	Cerulean blue	Winsor blue	Payne's gray

overpainting effects

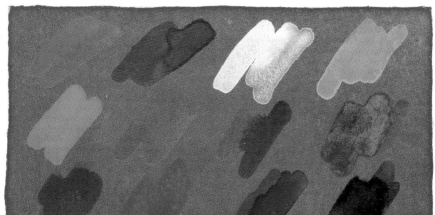

45

Mixing purples

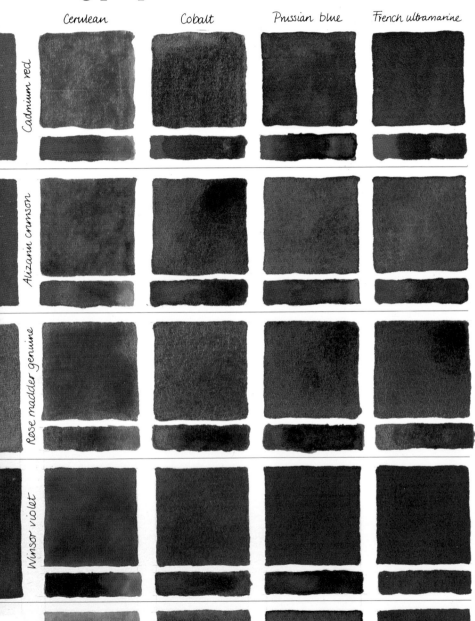

	Cerulean	Cobalt	Prussian blue	French ultramarine
Cadmium red				
Alizarin crimson				
Rose madder genuine				
Winsor violet				

The proportions of the pigment mixtures have been chosen to produce the most satisfactory purples. See pages 4 and 5 for more information.

Winsor blue	Indigo	Cobalt violet	Winsor violet

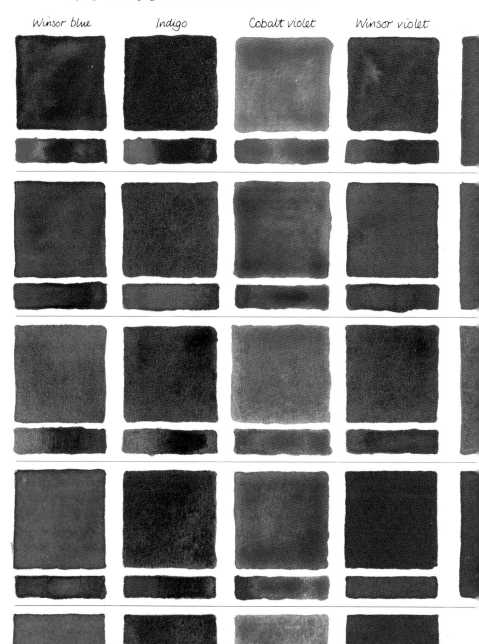

Raw sienna

Cadmium red	Alizarin crimson
Lemon yellow	Cadmium yellow
Yellow ochre	Burnt sienna
Burnt umber	Viridian
Cobalt blue	Cerulean blue
Winsor blue	Payne's gray

Cadmium red

Alizarin crimson

Lemon yellow

Cadmium yellow

Yellow ochre

Burnt sienna

Burnt umber

Viridian

Cobalt blue

Cerulean blue

Winsor blue

Payne's gray

overpainting effects

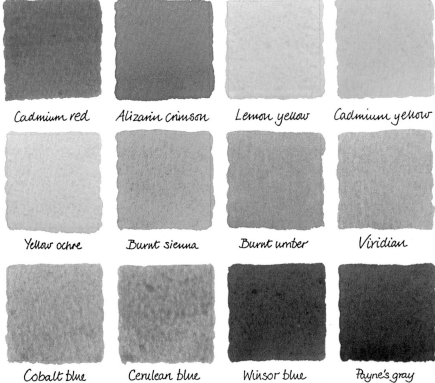

48

Raw umber

Cadmium red

Alizarin crimson

Lemon yellow

Cadmium yellow

Yellow ochre

Burnt sienna

Burnt umber

Viridian

Cobalt blue

Cerulean blue

Winsor blue

Payne's gray

overpainting effects

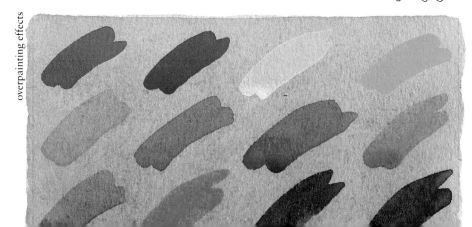

49

Burnt sienna

Cadmium red

Alizarin crimson

Lemon yellow

Cadmium yellow

Yellow ochre

Burnt sienna

Burnt umber

Viridian

Cobalt blue

Cerulean blue

Winsor blue

Payne's gray

overpainting effects

50

Cadmium red

Alizarin crimson

Lemon yellow

Cadmium yellow

Yellow ochre

Burnt sienna

Burnt umber

Viridian

Cobalt blue

Cerulean blue

Winsor blue

Payne's gray

overpainting effects

51

Burnt umber

Cadmium red Alizarin crimson Lemon yellow Cadmium yellow

Yellow ochre Burnt sienna Burnt umber Viridian

Cobalt blue Cerulean blue Winsor blue Payne's gray

overpainting effects

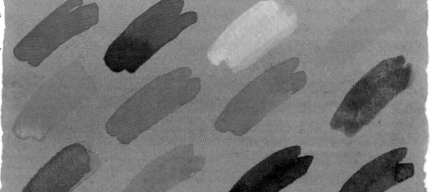

52

| Cadmium red | Alizarin Crimson | Lemon yellow | Cadmium yellow |

| Yellow ochre | Burnt sienna | Burnt umber | Viridian |

| Cobalt blue | Cerulean blue | Winsor blue | Payne's gray |

overpainting effects

Red Flag Markers, Whitby

21ins × 28ins

THE GENTLE, nostalgic atmosphere is emphasized by the use of soft brown tones reminiscent of a sepia photograph. The artist has used washes of raw sienna in various strengths, and this, mixed with the other pigments, creates a muted palette which helps to unify the whole painting. The colour has also been used for the surface of the water, reflecting the brown tones of the fishing boats and the quayside, and merging almost imperceptibly with the soft greys.

▼ *The distant hills, disappearing into the mist, are painted with thin washes of cobalt and a drop of permanent rose. Cobalt was preferred to cerulean in this case as it is more transparent.*

◀ *The sunlit areas of the buildings are painted with mixed washes of raw sienna and permanent rose. Details and cool shadows are defined with thin washes of cobalt, while warmer details have touches of cadmium yellow.*

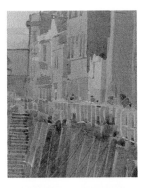

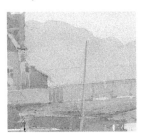

▶ *A base wash of raw sienna has again been used for the whole quayside, with highlights overpainted with a cadmium yellow wash. The green mossy walls are mixes of raw sienna, cerulean and viridian, and the deep shadow areas are wet in wet applications of French ultramarine, used for its transparent quality.*

▲ *To achieve the effect of shimmering water the artist used washes, some being worked wet in wet. They consist of mixes of cerulean, cobalt and raw sienna, with delicate touches of viridian and permanent rose.*

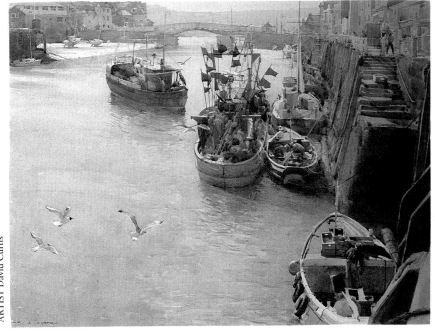

ARTIST David Curtis

◀ *Even the red flags, which act as colour highlights, are muted, the cadmium red being subdued by adding a small amount of raw sienna. White highlights sparkle throughout the whole painting. The artist used masking fluid to reserve small areas of white paper, a method which allows the washes to be applied freely.*

 # Payne's gray

Cadmium red

Alizarin crimson

Lemon yellow

Cadmium yellow

Yellow ochre

Burnt sienna

Burnt umber

Viridian

Cobalt blue

Cerulean blue

Winsor blue

Payne's gray

overpainting effects

56

Davy's gray

Cadmium red Alizarin crimson Lemon yellow Cadmium yellow

 Burnt sienna Burnt umber Viridian

Yellow ochre

Cobalt blue Cerulean blue Winsor blue Payne's gray

overpainting effects

57

MUTED COLOURS

Fen Cottage
8ins × 12ins

THIS IS TAKEN from a sketchbook, and shows the art of mixing colours very clearly. The artist has used the actual page as a palette on which to mix and drop in the fluid colours. A very limited selection of colours was used to convey a dull winter's day. The cool colours — ultramarine, indigo and Paynes gray — and the spiky, linear pencil drawing emphasizes the bleak atmosphere, but this is cleverly counterbalanced by thin washes and mixes of alizarin crimson and yellow ochre, giving the painting slight touches of warmth.

▷ *A thin dilution of yellow ochre formed the base colour of the sky, with thin touches of ultramarine and crimson added to create variety.*

▼ *The basis of the whole painting can be seen in this detail: the artist has used various mixes of ultramarine, indigo, alizarin crimson and yellow ochre to create the desired cool and warm tones.*

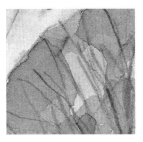

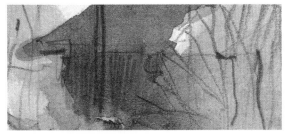

▲ *The skeleton drawing of the tree is given substance by washes of yellow ochre and ultramarine, with a little alizarin crimson for warmth.*

◀ *Dots and blobs of white gouache were used to depict the blossom on the leafless tree.*

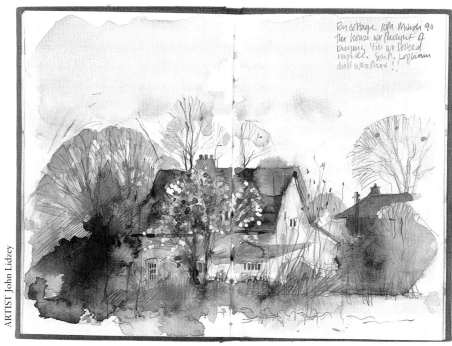

◀ *The subtle green hues have been achieved by mixes of aureolin yellow and indigo.*

 # Ivory black

Ivory black is better than lamp black for mixtures as it is less dense.

Cadmium red

Alizarin crimson

Lemon yellow

Cadmium yellow

Yellow ochre

Burnt sienna

Burnt umber

Viridian

Cobalt blue

Cerulean blue

Winsor blue

Payne's gray

overpainting effects

Chinese white

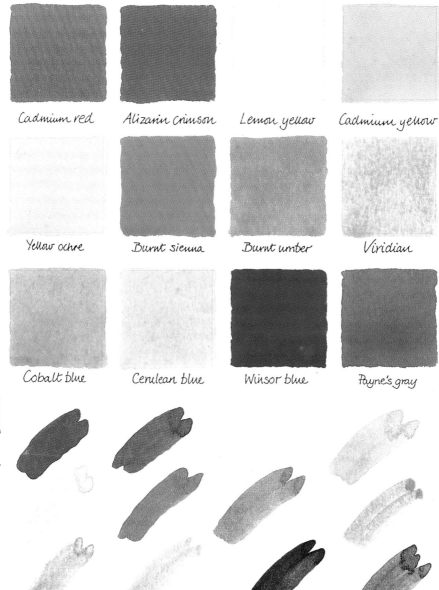

Cadmium red	Alizarin crimson	Lemon yellow	Cadmium yellow
Yellow ochre	Burnt sienna	Burnt umber	Viridian
Cobalt blue	Cerulean blue	Winsor blue	Payne's gray

USEFUL MIXES: SKIN

SKIN TONES vary enormously: from one race to another, within the same racial group, from male to female, and even from one part of the body to another. The variety is made even wider by the light under which a particular person is seen, because skin will reflect light and also take on a certain amount of colour from the surrounding hues. Thus the artist can use a whole range of colours, from yellow and reds in the highlights to blues, violets and greens in the shadows.

Experienced artists have their own favourite mixtures, but beginners often do not know where to start. These pages show five suggested skin tone mixtures with highlights and shadows for each.

Main colour mixture
1 Yellow ochre
2 Alizarin crimson

*Highlights show
the main colour plus*
3 Lemon yellow
4 Cadmium yellow
5 Cadmium red

*Shadows show the
main colour plus*
6 Cobalt blue
7 Paynes gray
8 Viridian

Main colour mixture
1 Raw sienna
2 Rose doré

*Highlights show
the main colour plus*
3 Lemon yellow
4 Cadmium yellow
5 Cadmium red

*Shadows show the
main colour plus*
6 Cobalt blue
7 Paynes gray
8 Viridian

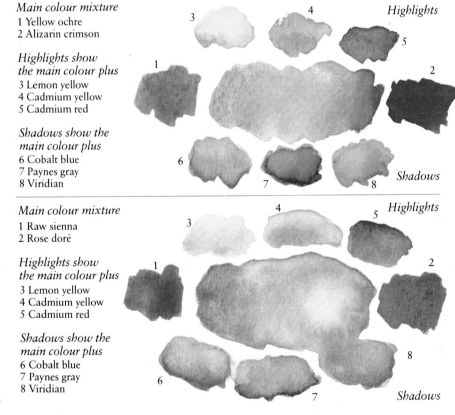

Highlights

Shadows

Highlights

Shadows

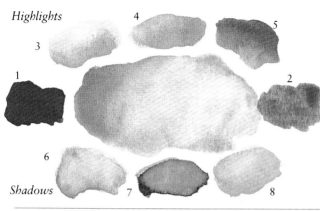

Highlights

Shadows

Main colour mixture
1 Alizarin crimson
2 Raw sienna

*Highlight mixtures
show main colour plus*
3 Lemon yellow
4 Cadmium yellow
5 Cadmium red

*Shadow mixtures show
main colour plus*
6 Cobalt blue
7 Paynes gray
8 Viridian

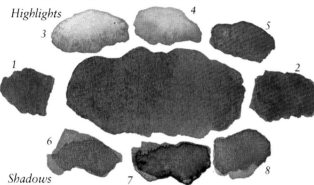

Highlights

Shadows

Main colour mixture
1 Cobalt blue
2 Burnt umber

*Highlight mixtures
show main colour plus*
3 Lemon yellow
4 Cadmium yellow
5 Cadmium red

*Shadow mixtures show
main colour plus*
6 Cobalt blue
7 Paynes gray
8 Viridian

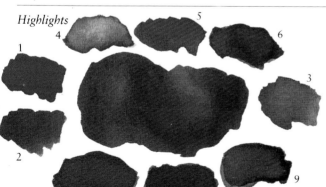

Highlights

Shadows

Main colour mixture
1 Alizarin crimson
2 Sepia
3 Indigo

*Highlight mixtures
show main colour plus*
4 Lemon yellow
5 Cadmium red

*Shadow mixtures show
main colour plus*
7 Winsor violet
8 French
ultramarine
9 Viridian

CREDITS

CONTRIBUTING ARTISTS
16 Christopher Baker; 24 Moira Clinch; 34
Annie Williams (courtesy Canns Down
Press); 46 Moira Clinch; 54 David Curtis
(courtesy Richard Hagen, Broadway,
Worcestershire); 58 John Lidzey

Senior Editor
Hazel Harrison

Picture Research
Jane Lambert

Design Assistants
Penny Dawes
David Kemp
Kerry Davies

Colour charts
Sally Launder
Moira Clinch

Typeset by QV Typesetting, London
Printed in China by Leefung-Asco Printers Ltd

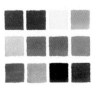